MEN IN UNIFORM
ADULT COLORING BOOK

M.G. ANTHONY

A POST HILL PRESS BOOK

ISBN: 978-1-68261-131-9

Men in Uniform Adult Coloring Book

© 2016 by M.G. Anthony

All Rights Reserved

Post Hill Press
275 Madison Avenue, 14th Floor
New York, NY 10016
posthillpress.com

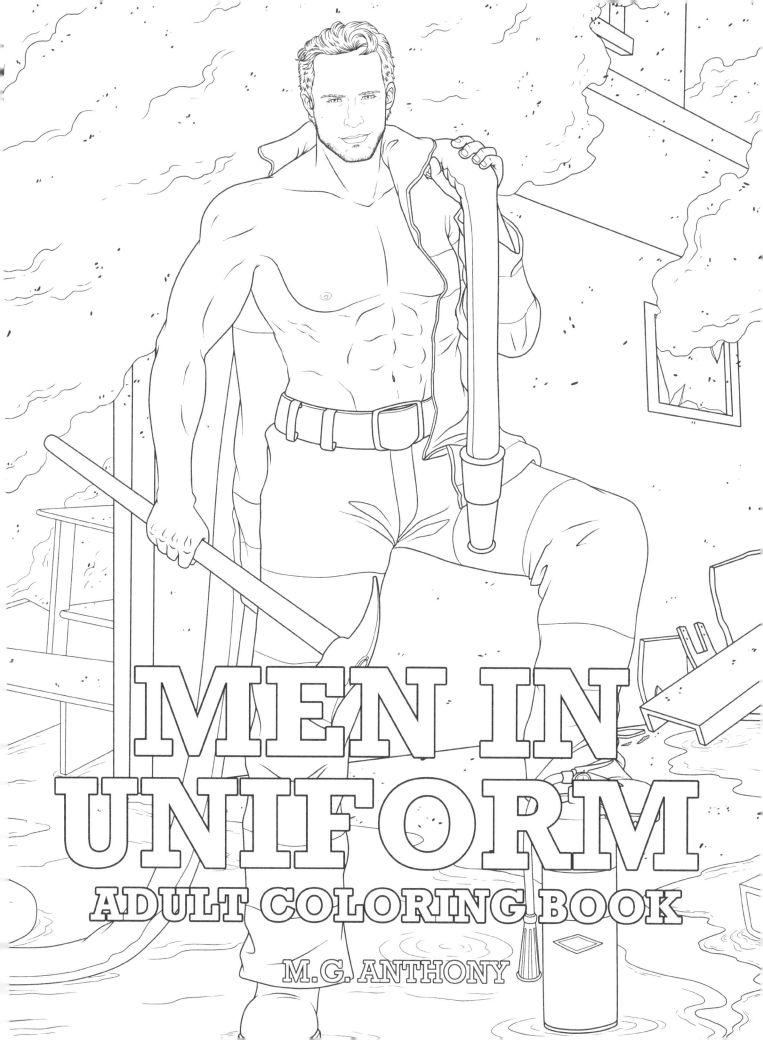

MEN IN UNIFORM

ADULT COLORING BOOK

M.G. ANTHONY

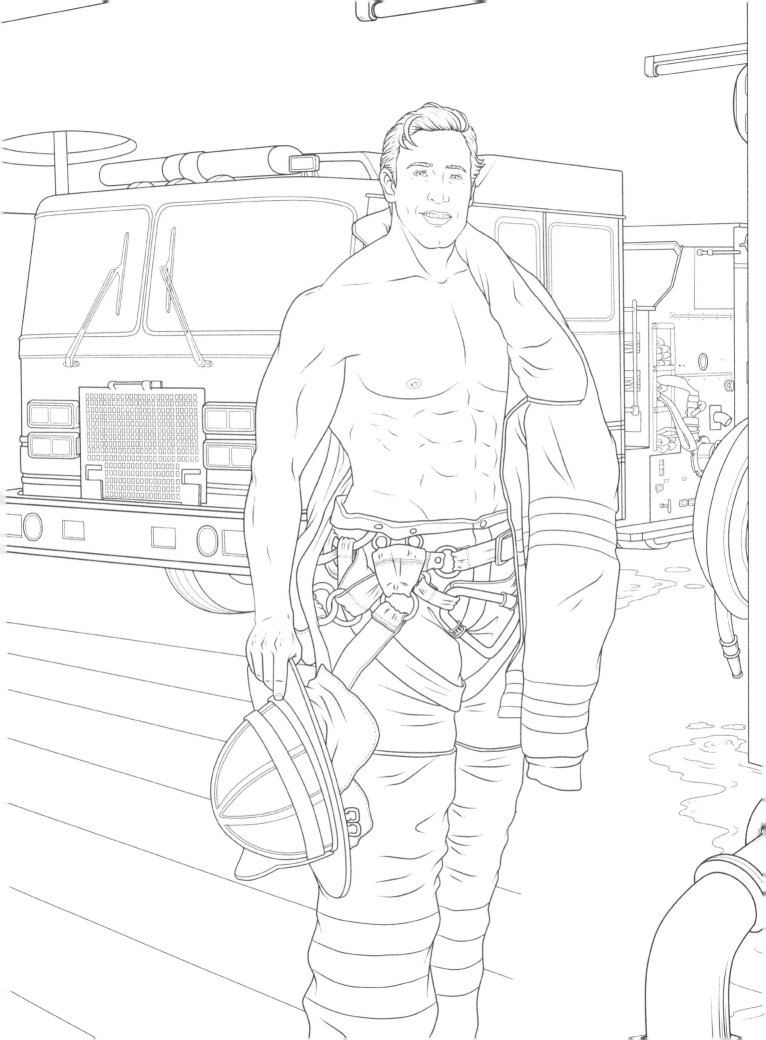

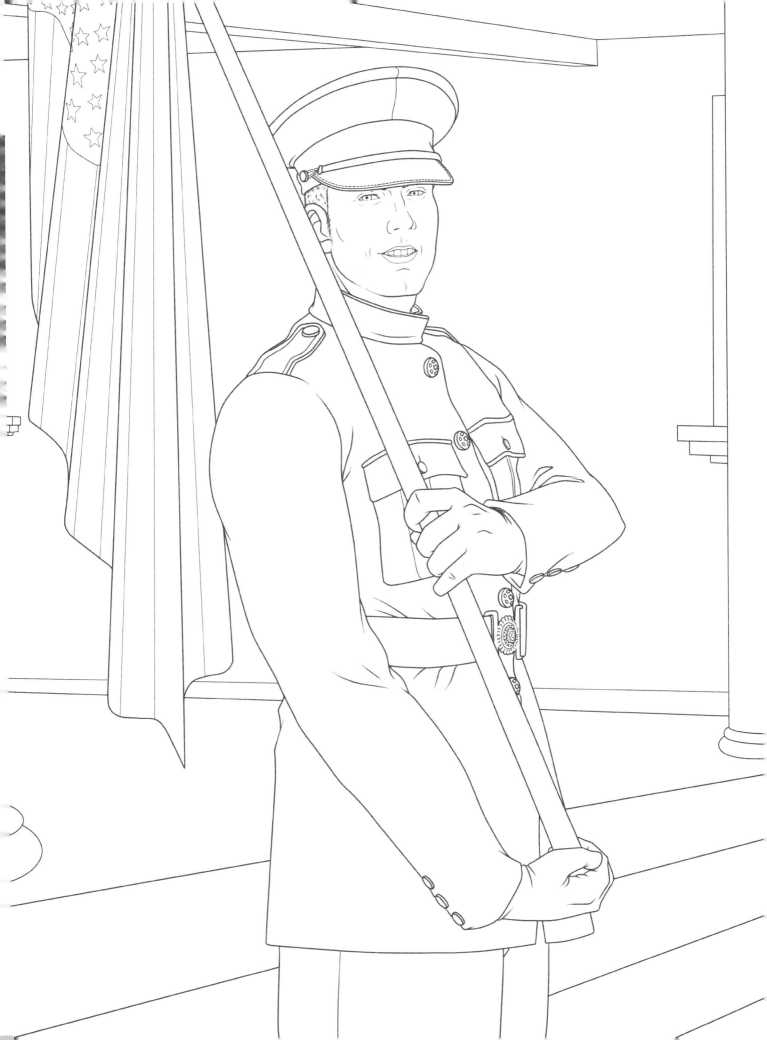

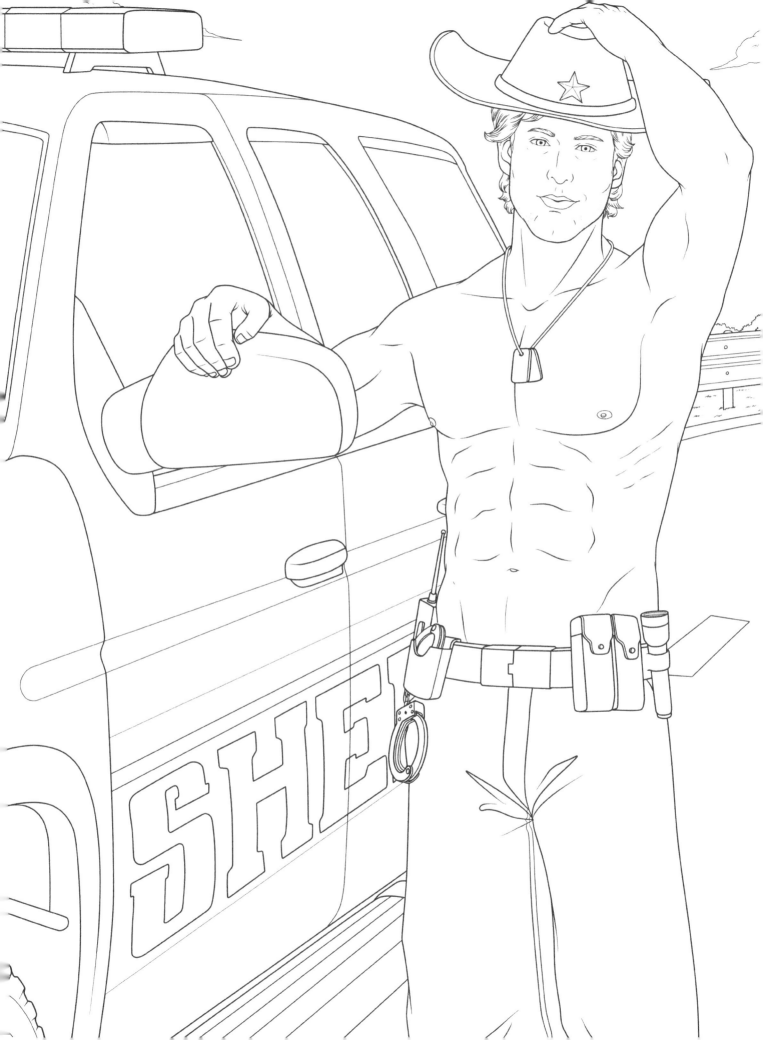

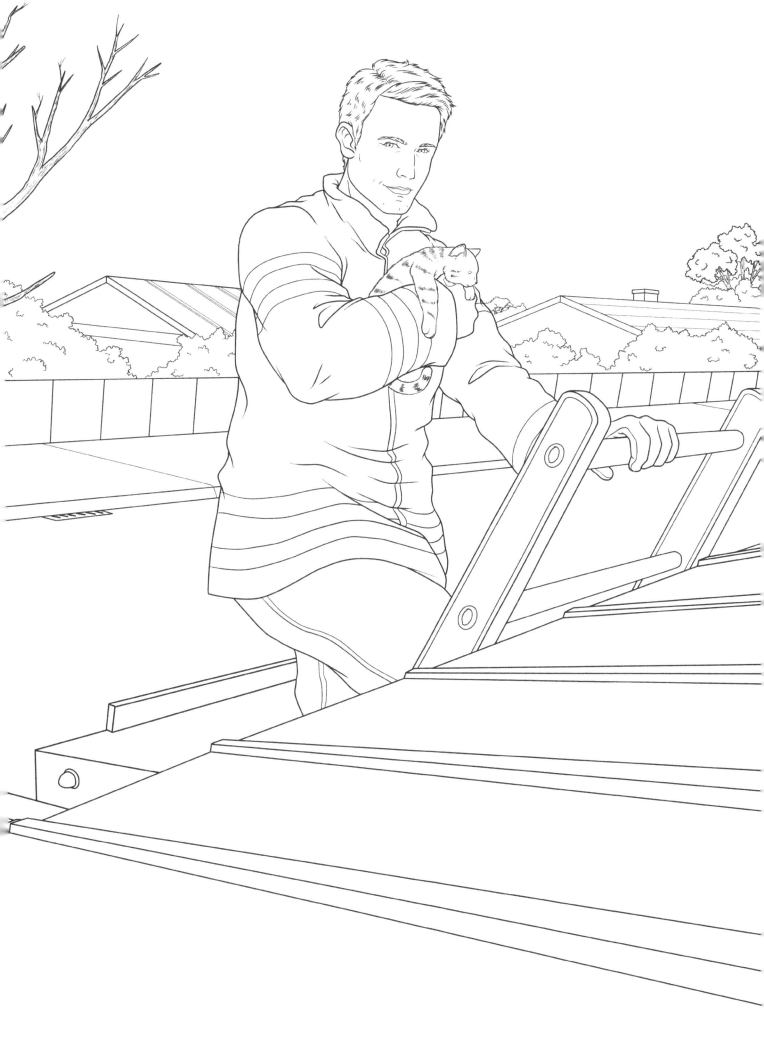

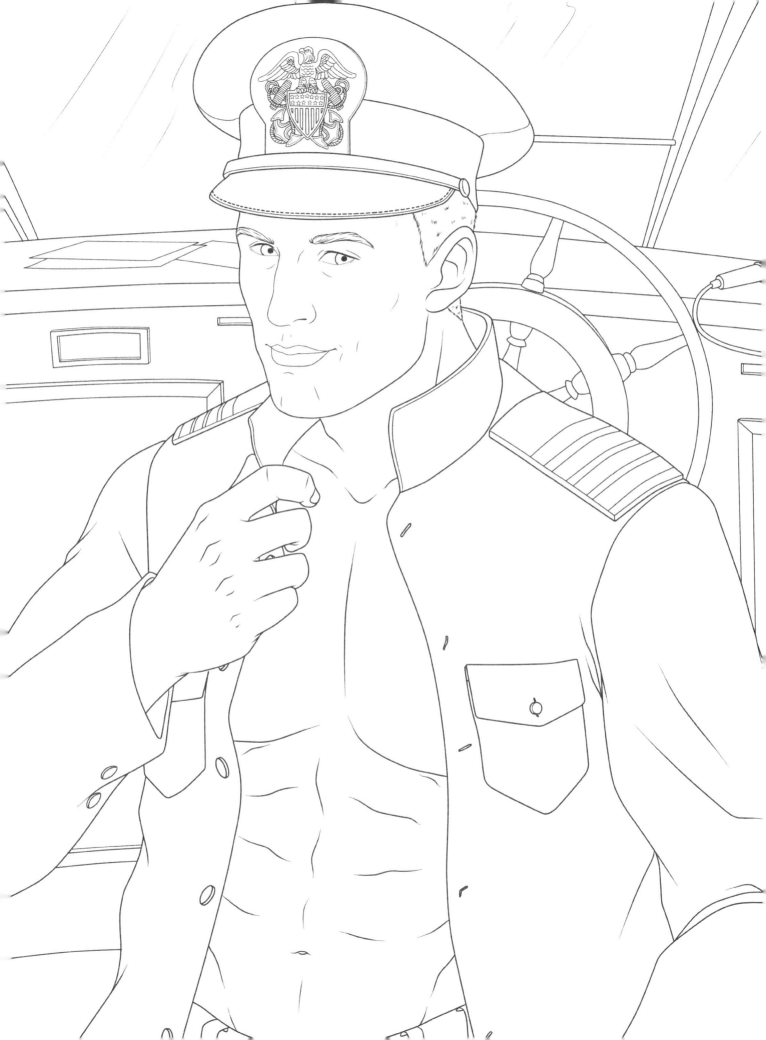

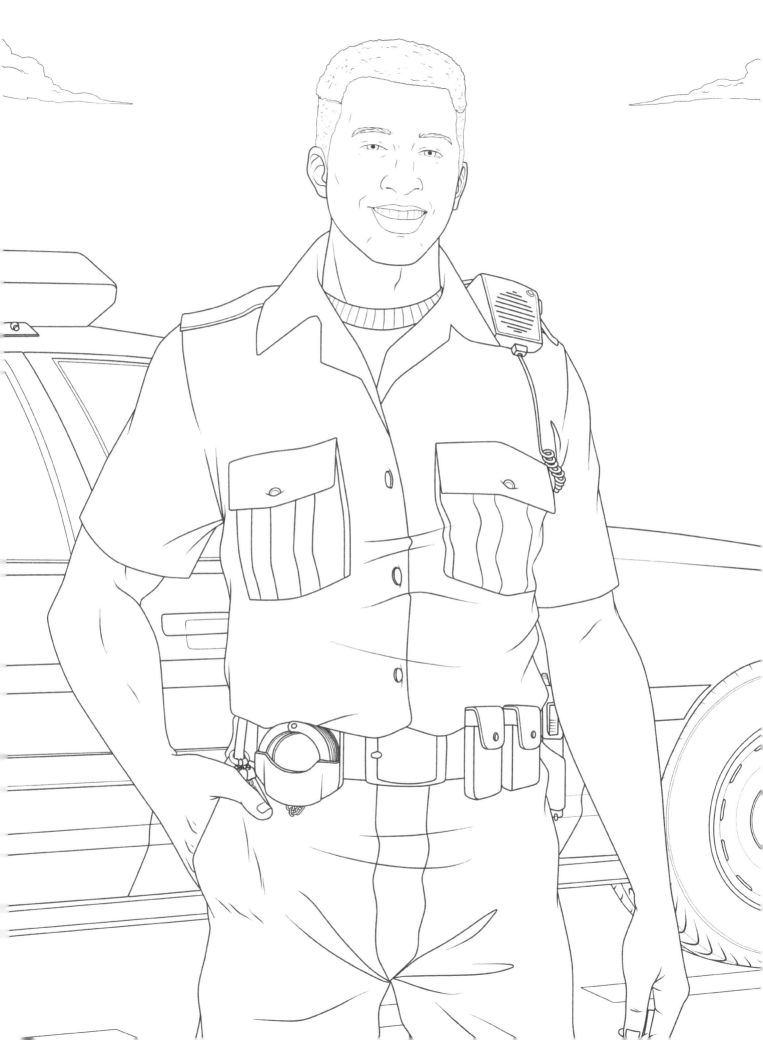

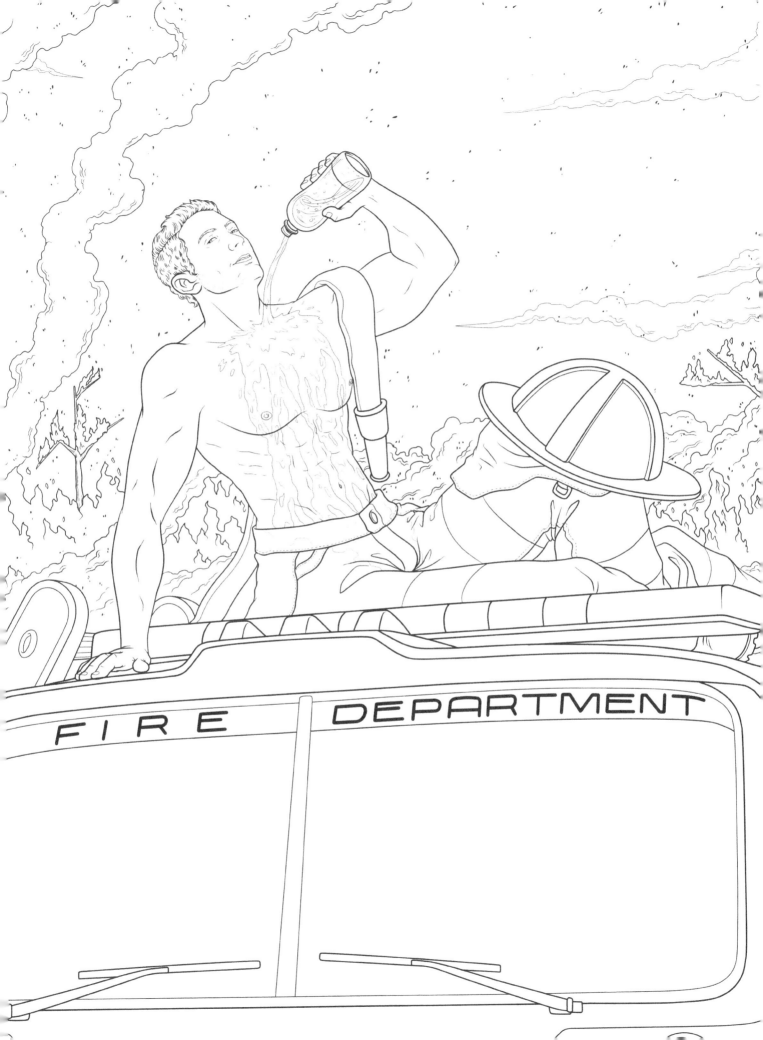

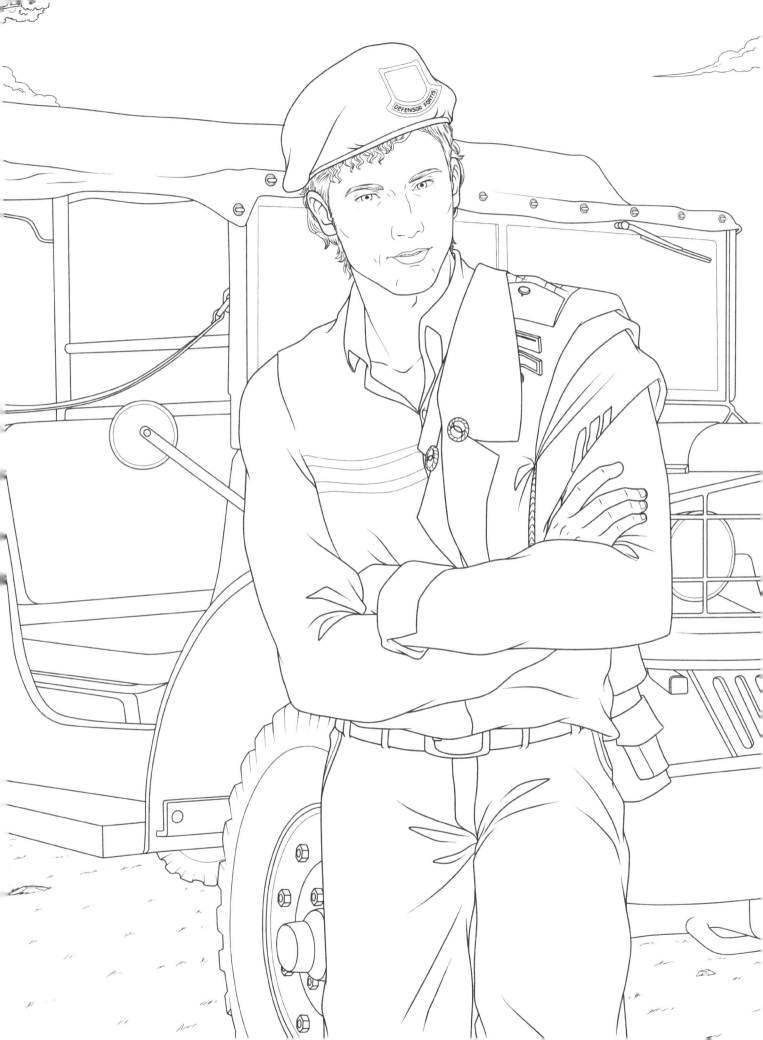

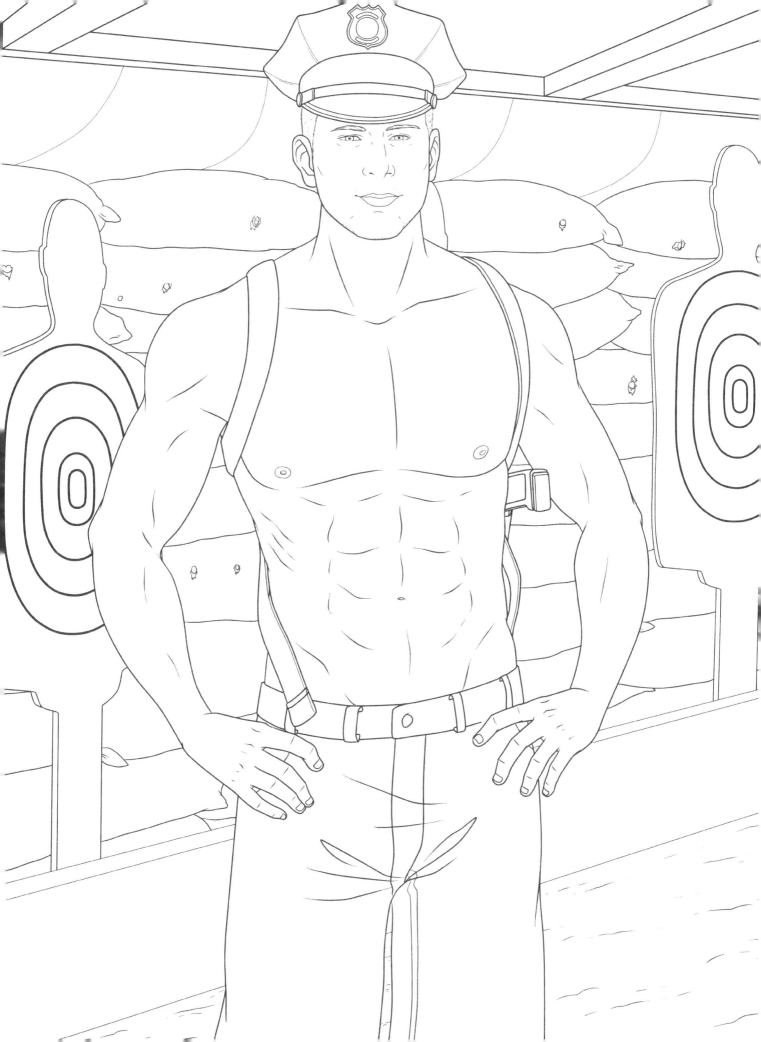

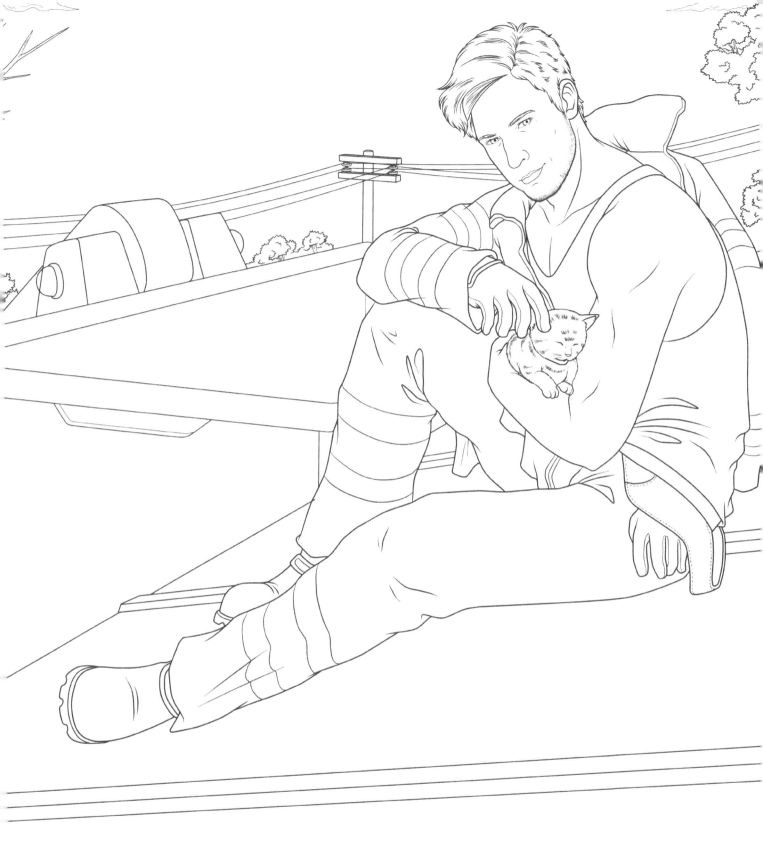

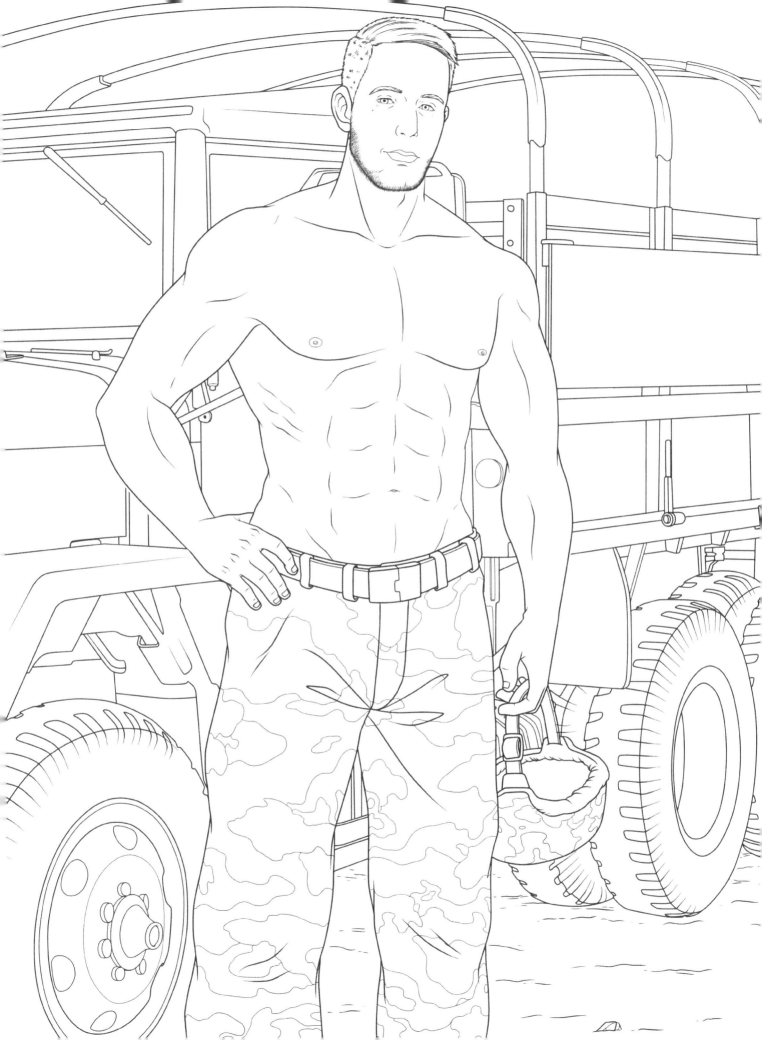

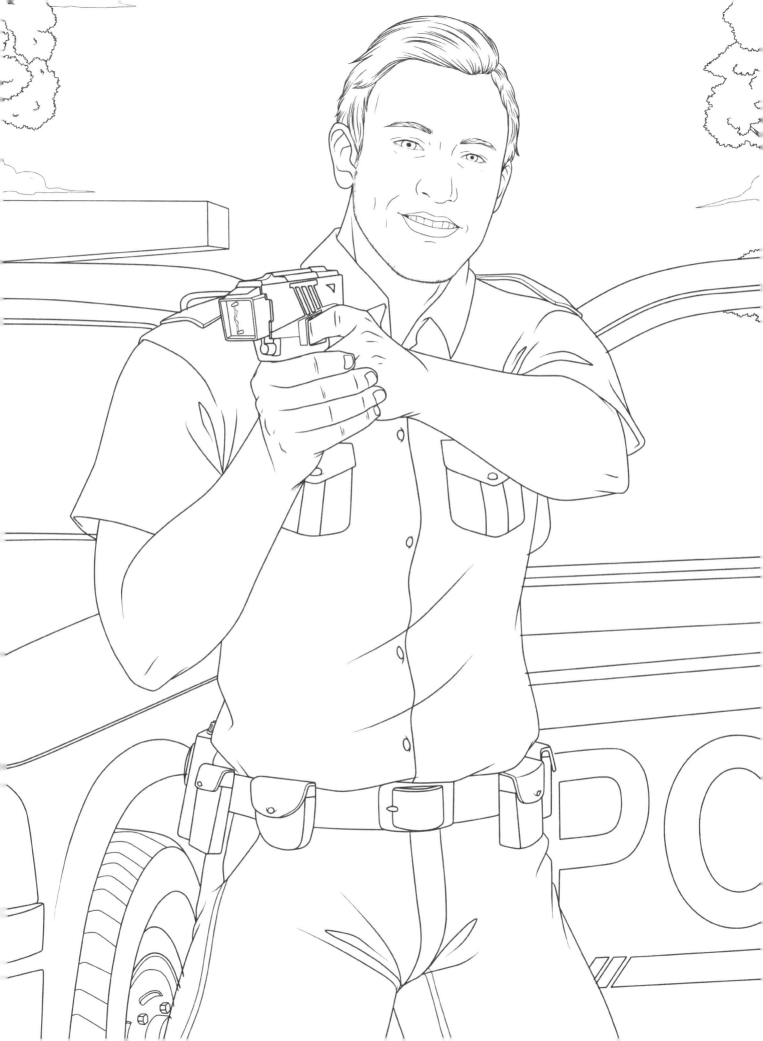

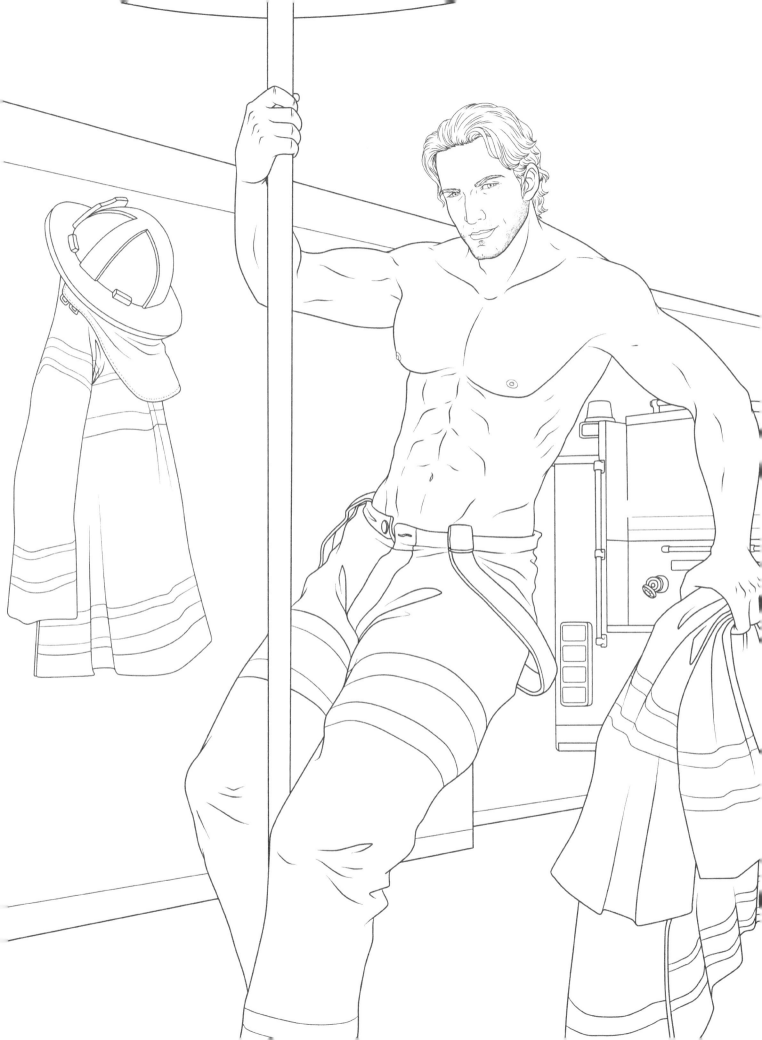

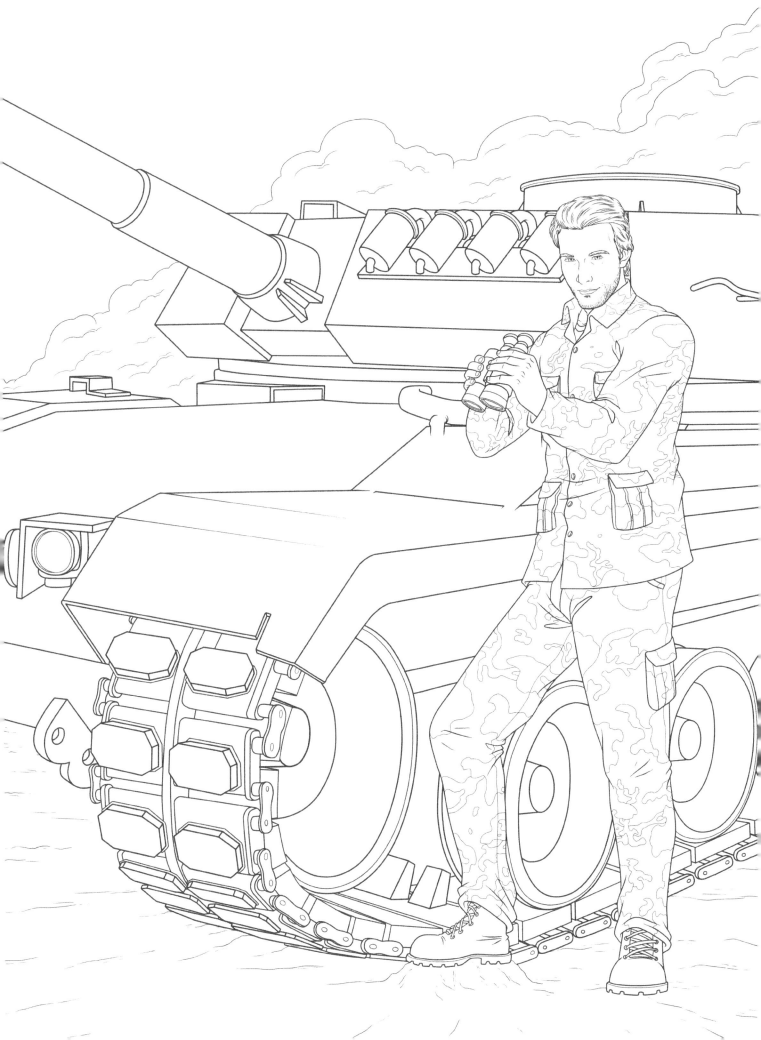

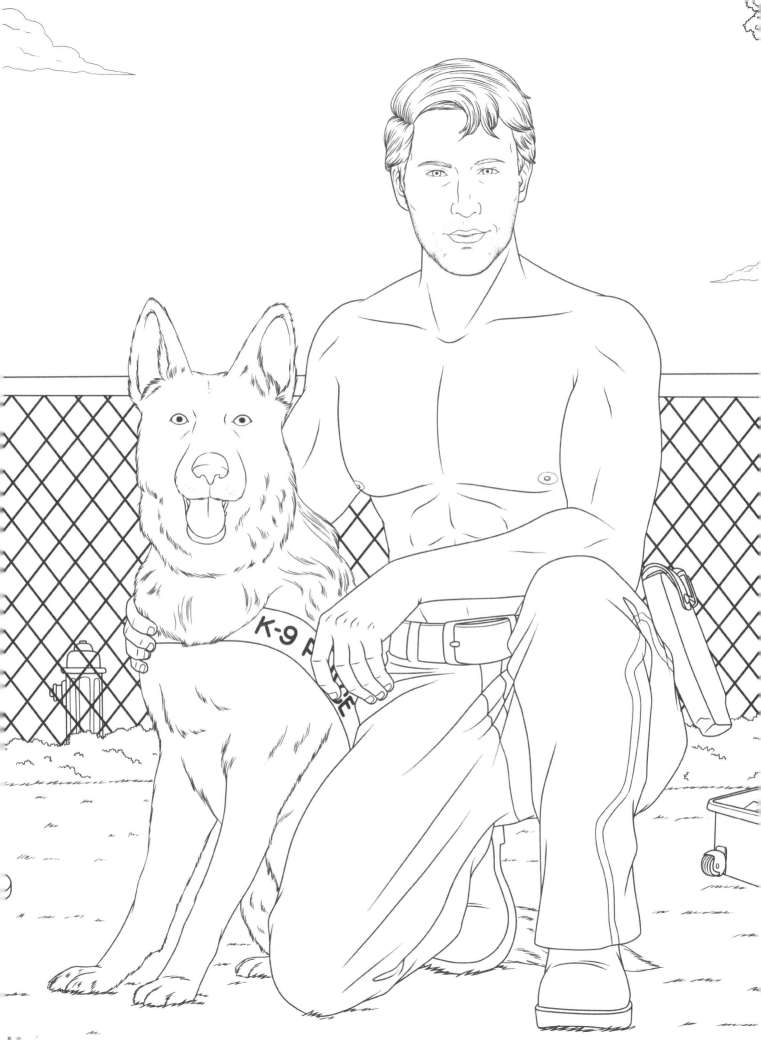

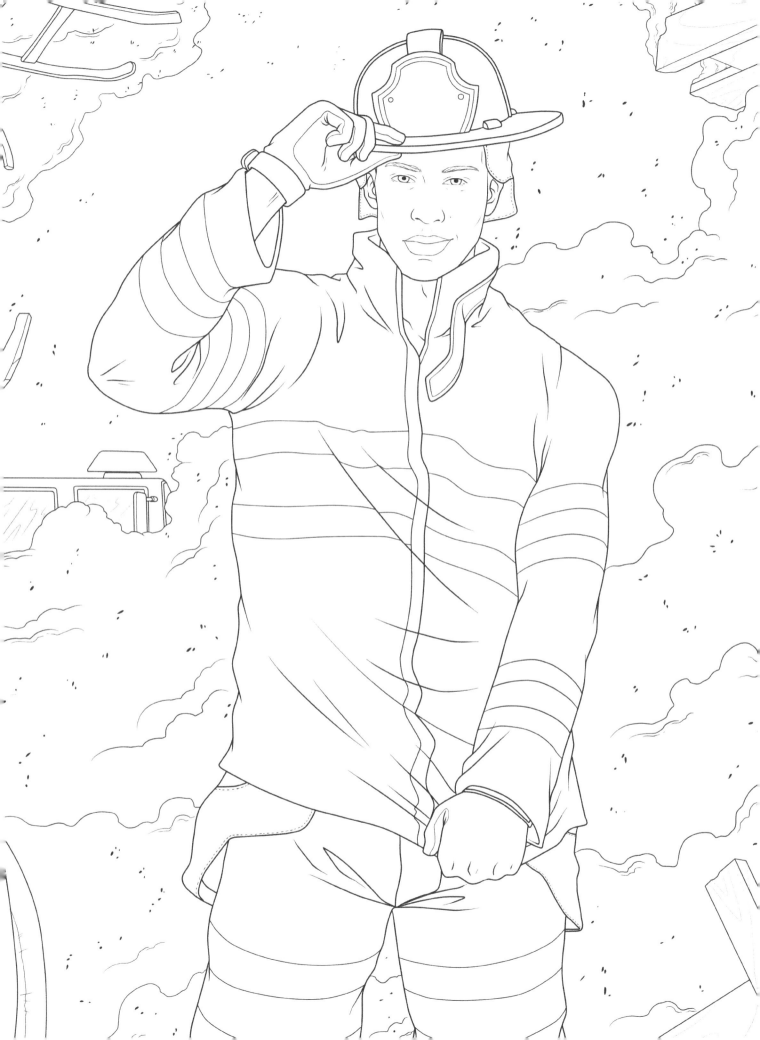

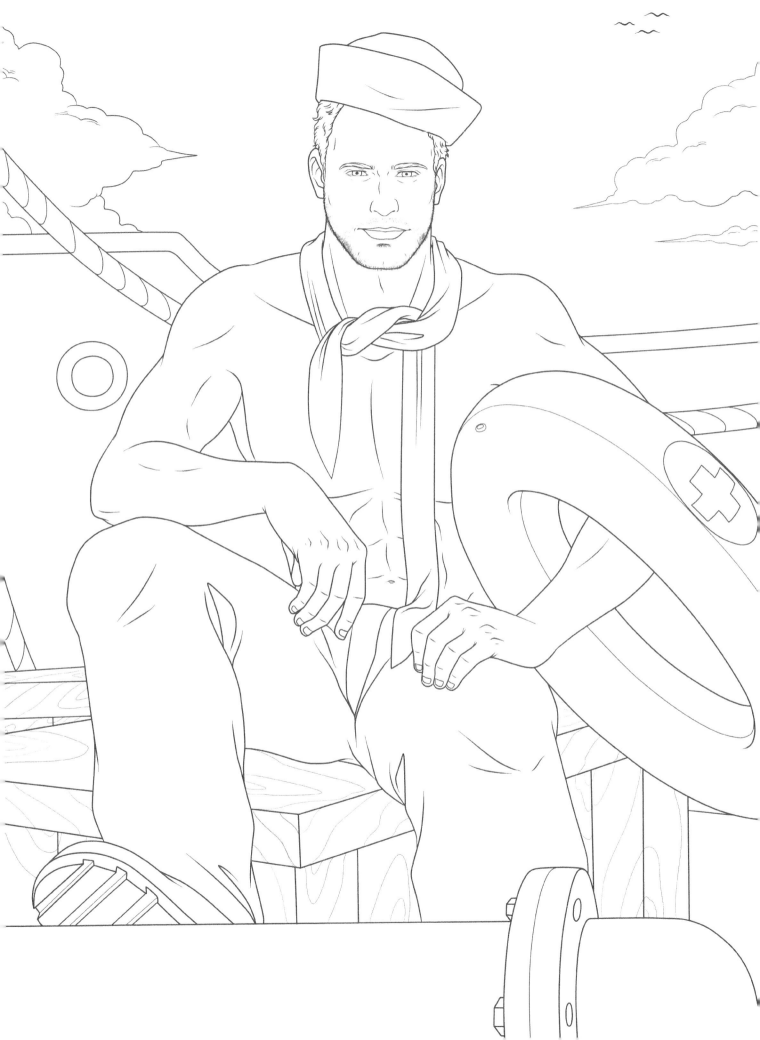

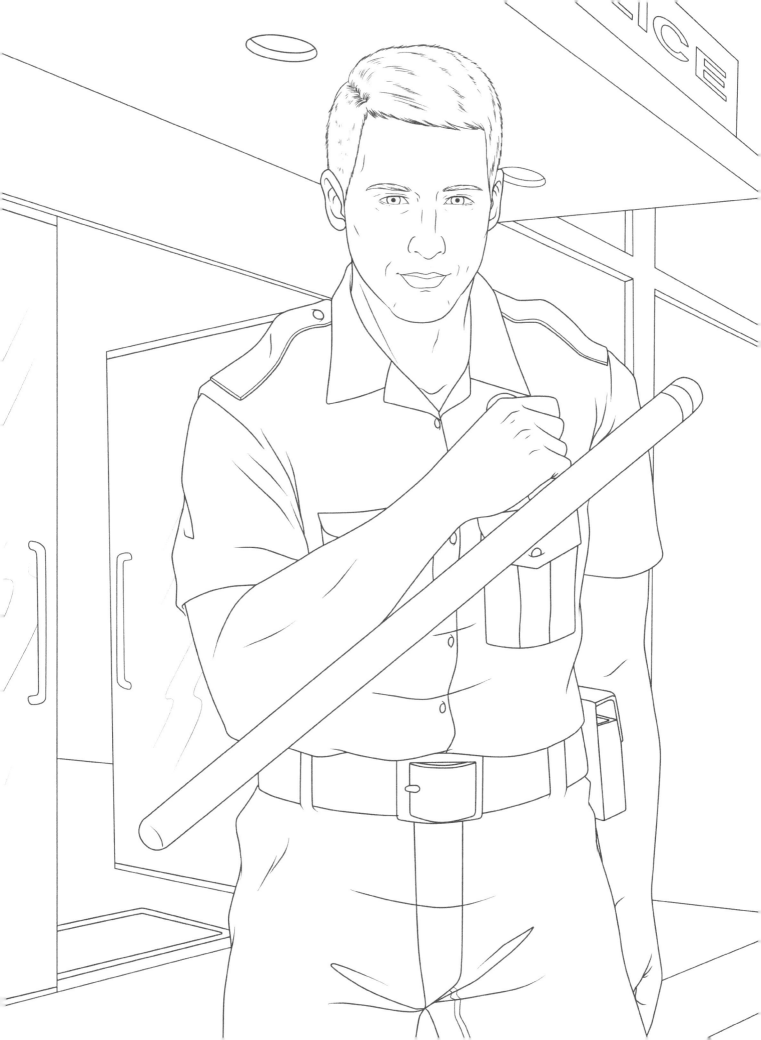

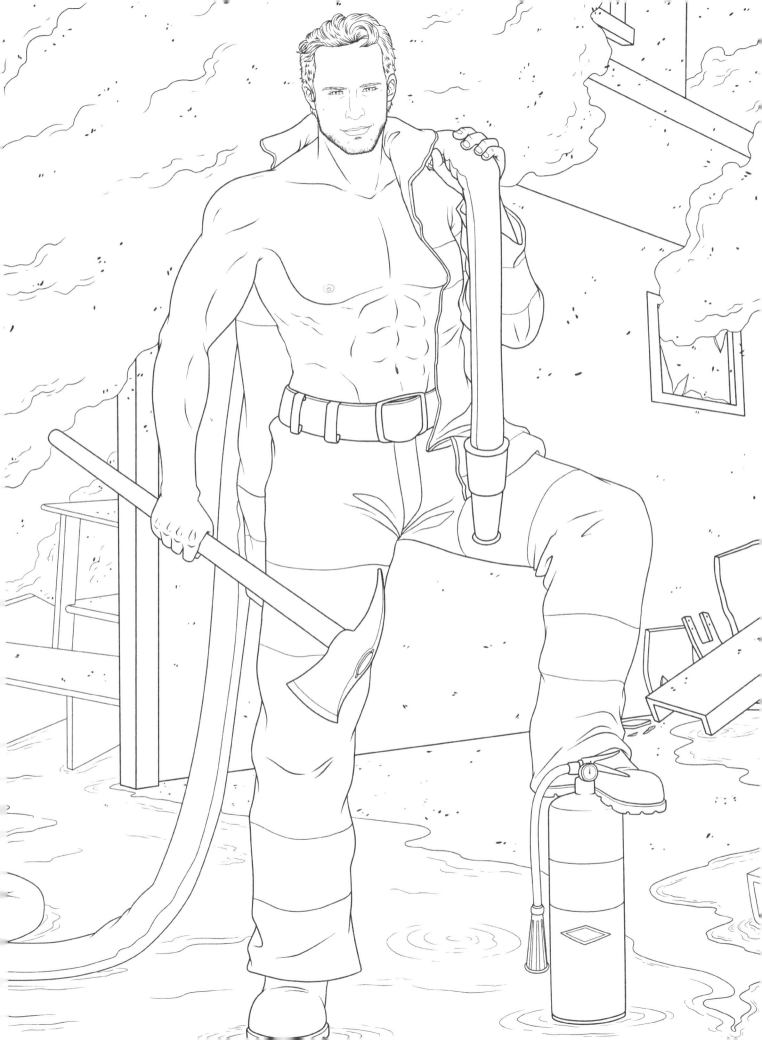

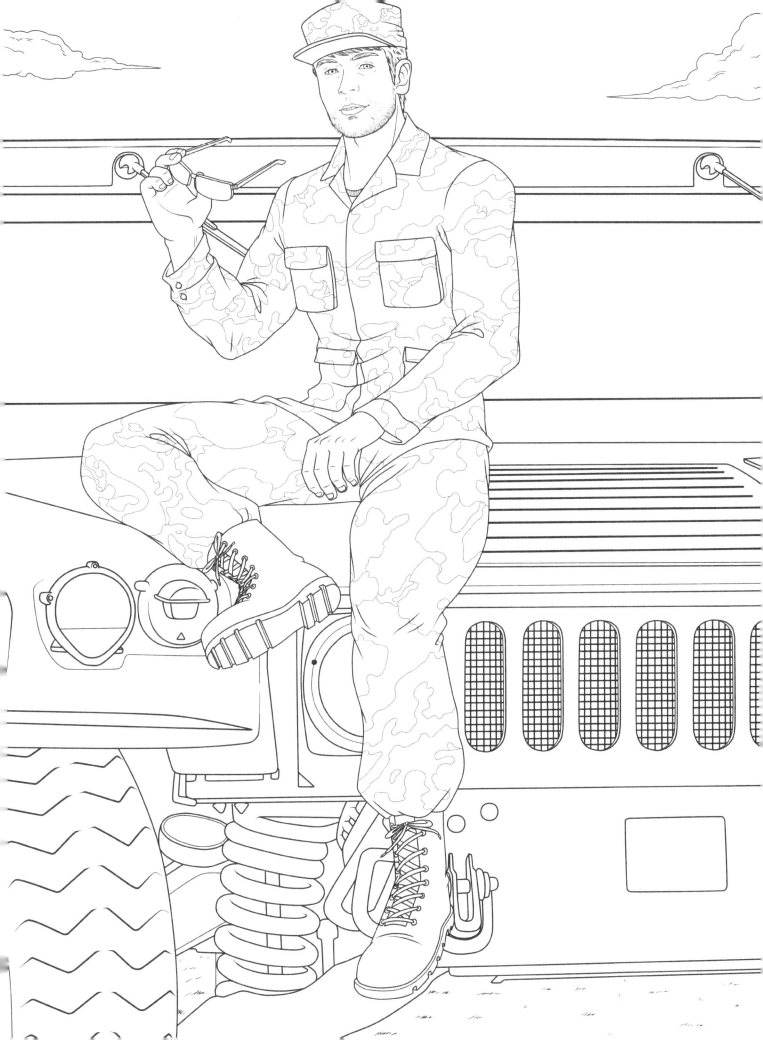

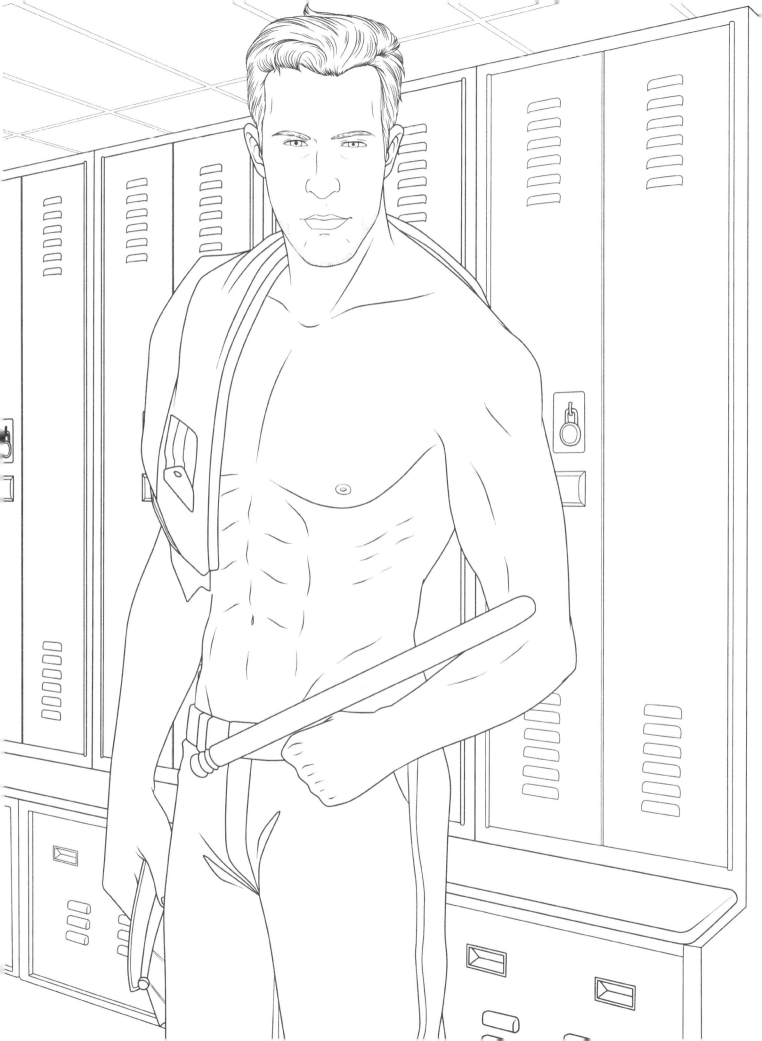

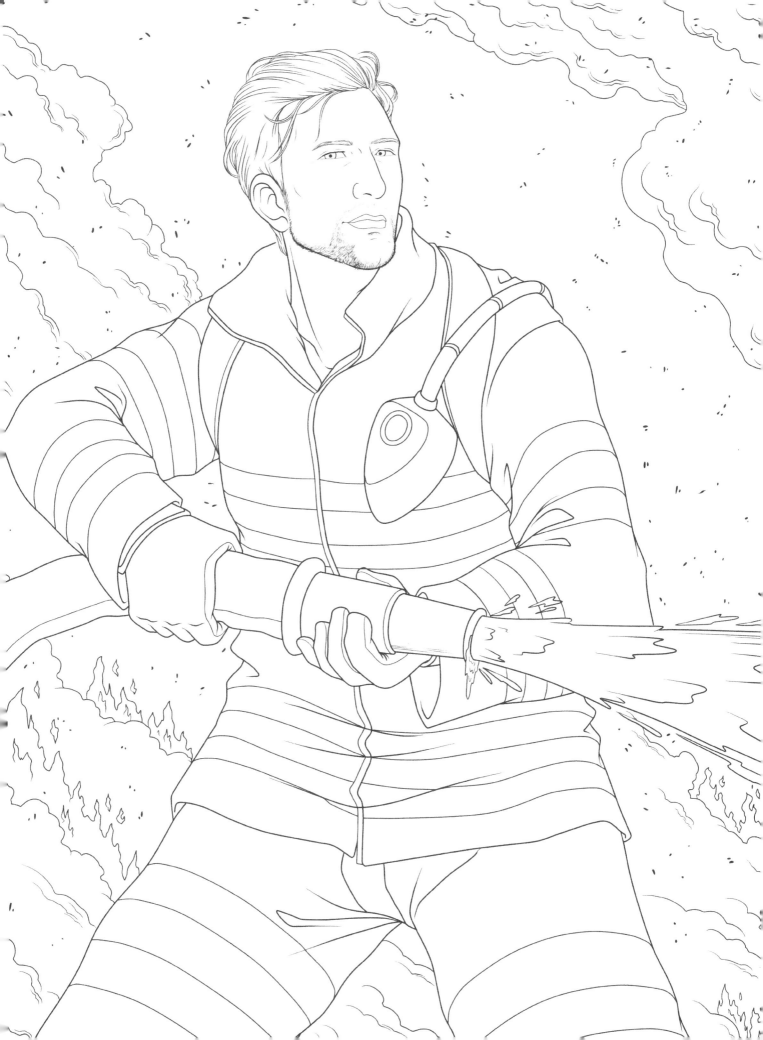

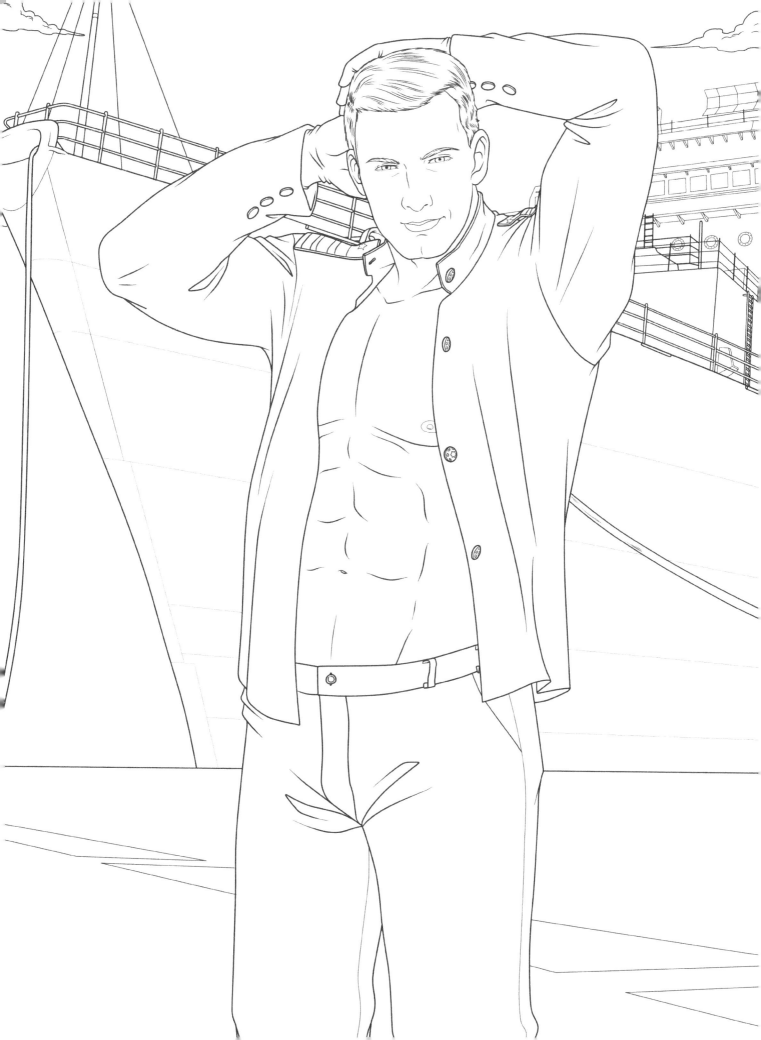

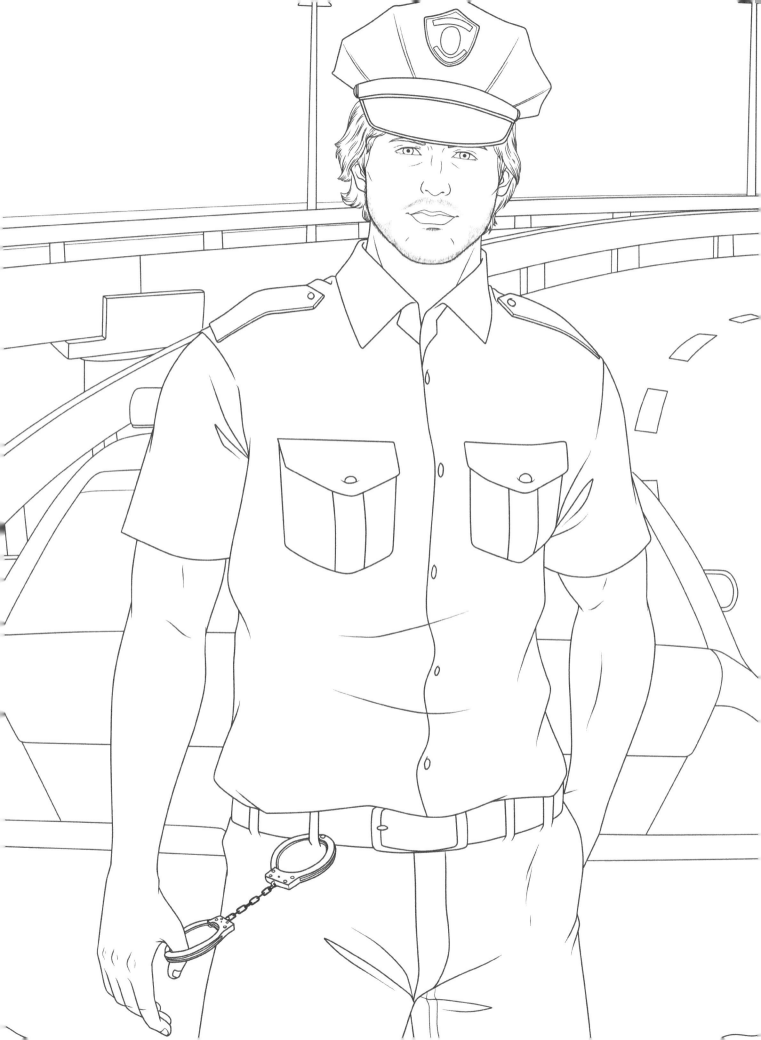

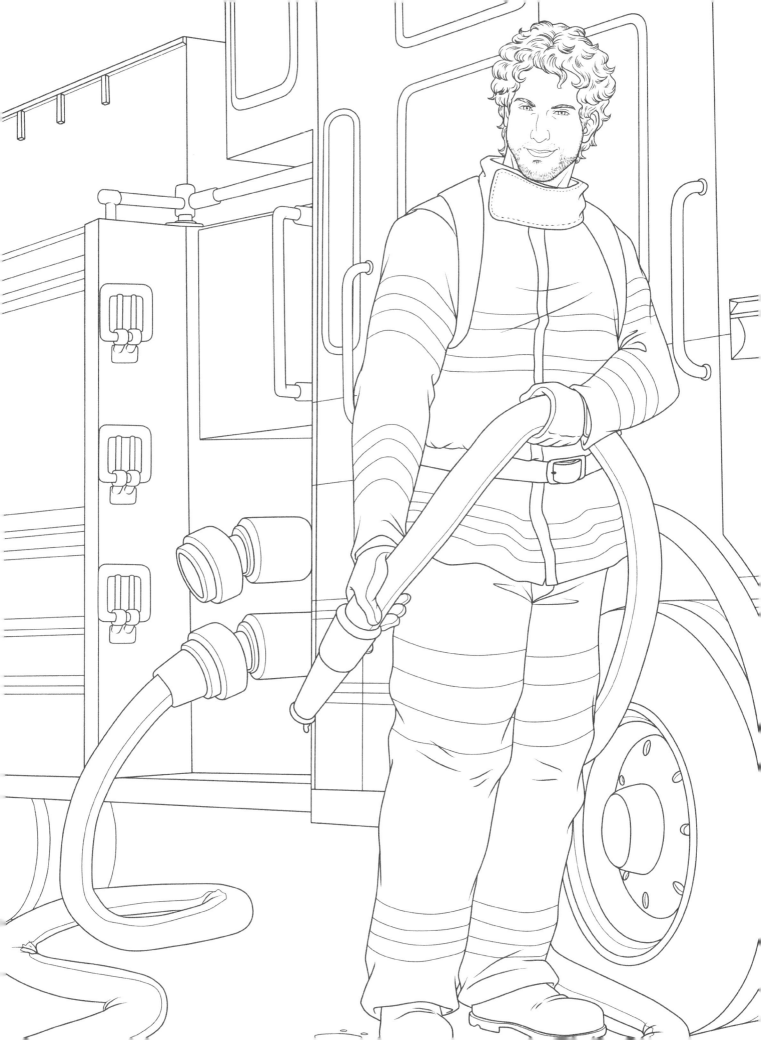

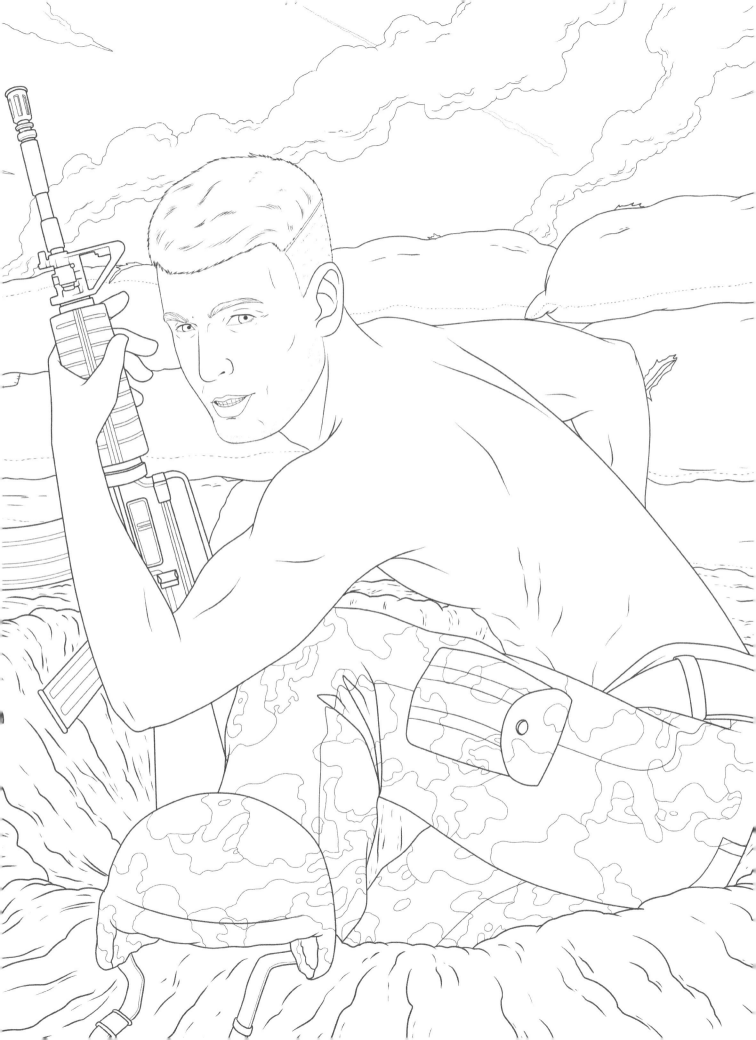

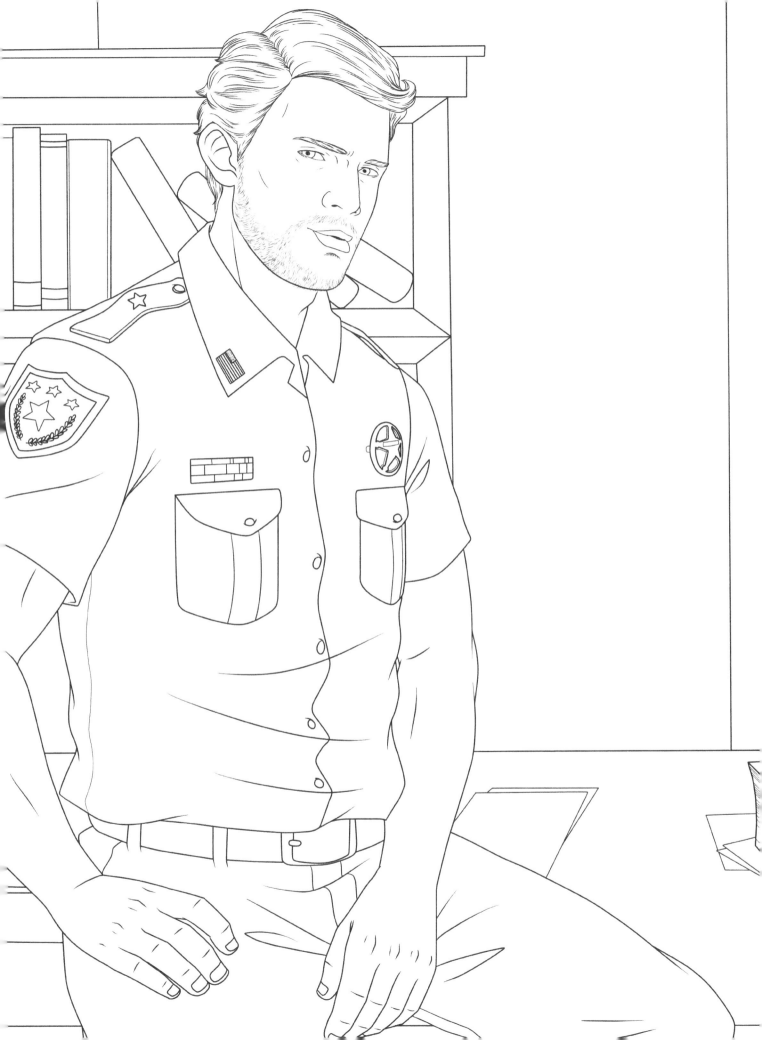

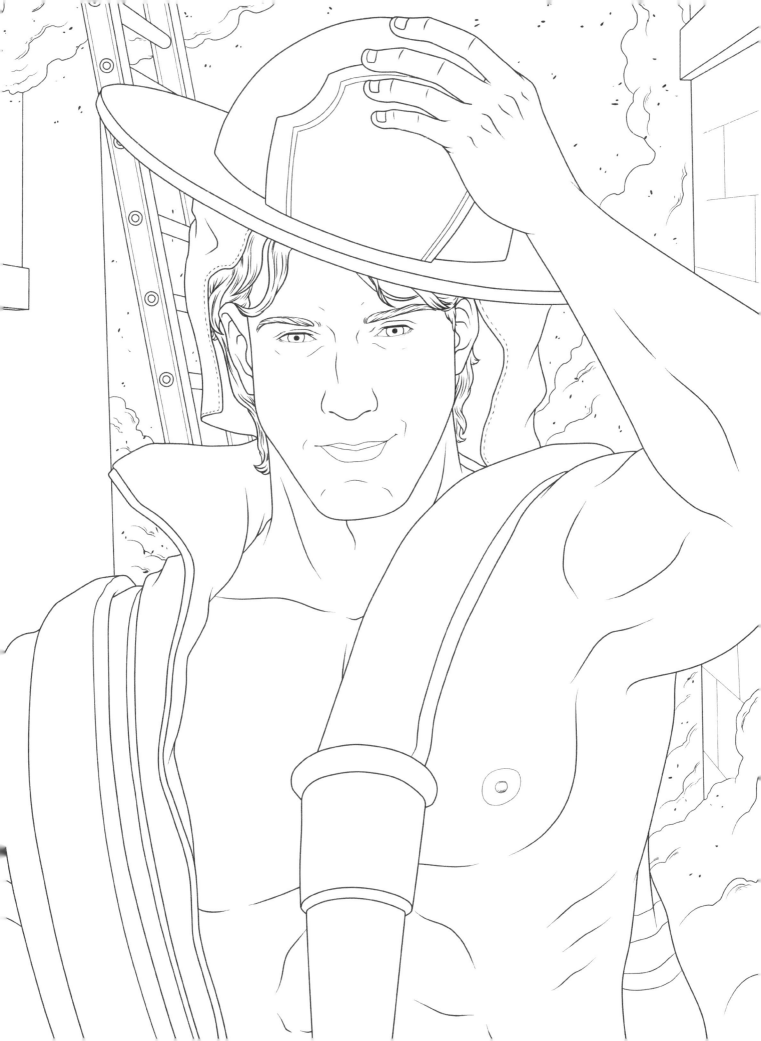

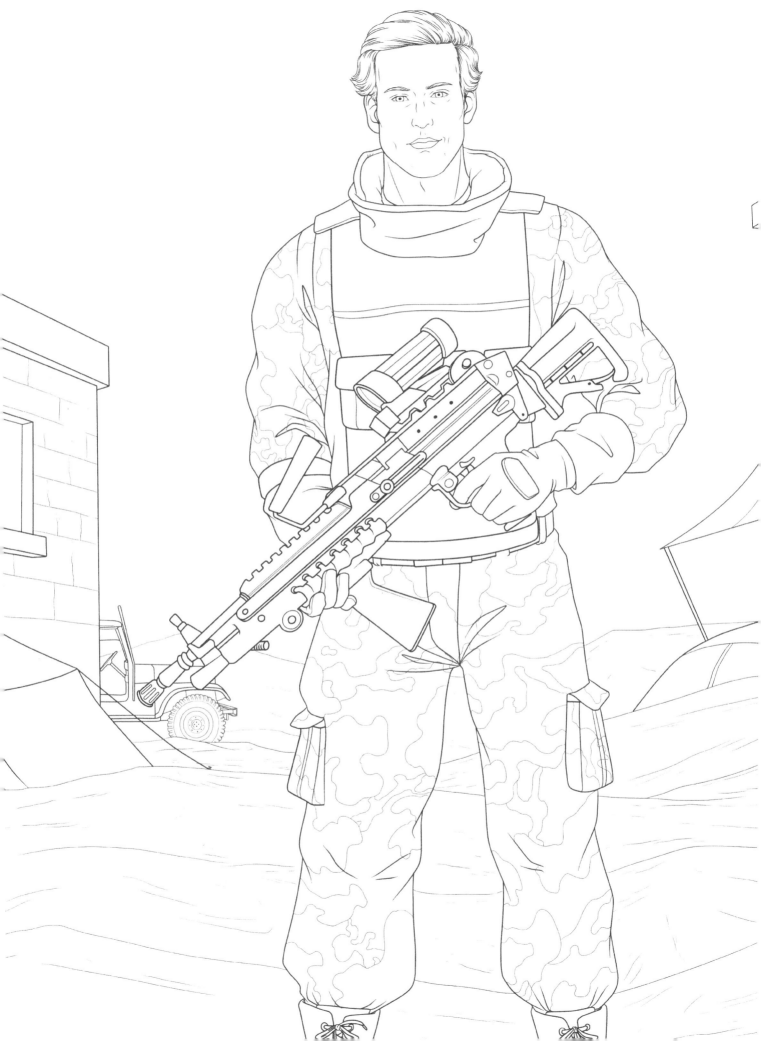

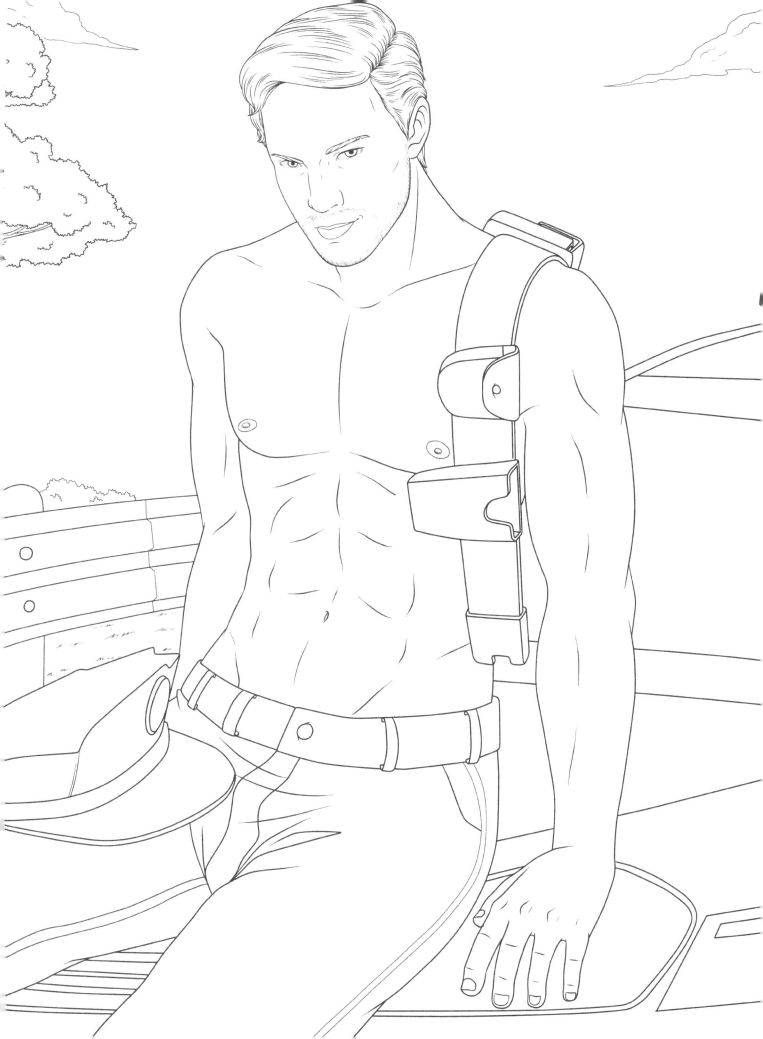